A coloring book and guide to prayer
by the best-selling author of *Praying in Color*

Pray *and* Color

Sybil MacBeth

PARACLETE PRESS
BREWSTER, MASSACHUSETTS

In Gratitude for the Life
of
Phyllis Tickle

The most colorful and prayerful woman I have known

2016 First printing

Pray and Color: A coloring book and guide to prayer by the best-selling author of Praying in Color

Copyright © 2016 by Sybil MacBeth

ISBN 978-1-61261-827-2

Unless otherwise marked, Scripture references are taken from the New Revised Standard Version Bible, copyright 1989, Division of Christian Education of the National Council of the Churches of Christ in the United States of America. Used by permission. All rights reserved.

Scriptures marked KJV are from the Authorized (King James) Version of the Holy Bible.

Quotations from The Roman Missal, Third Edition, are taken from The Roman Missal © 2010 International Commission on English in the Liturgy Corporation. All rights reserved.

The Paraclete Press name and logo (dove on cross) are trademarks of Paraclete Press, Inc.

10 9 8 7 6 5 4 3 2 1

All rights reserved. No portion of this book may be reproduced, stored in an electronic retrieval system, or transmitted in any form or by any means—electronic, mechanical, photocopy, recording, or any other—except for brief quotations in printed reviews, without the prior permission of the publisher.

Published by Paraclete Press
Brewster, Massachusetts
www.paracletepress.com

Printed in the United States of America

contents

Chapter	0	This Book Is for People Who . . .	4
Chapter	1	Coloring as a Spiritual Practice	5
Chapter	2	Coloring as Prayer	8
Chapter	3	The Coloring Pages / Templates	11
Chapter	4	Preparing to Pray	13
Chapter	5	Ways to Pray	15
Chapter	6	Prayer + Coloring + Doodling = Praying in Color	28

Chapter 0

This Book Is for People Who . . .

- like to color
- like to color but feel inadequate about their drawing or doodling skills
- like to color even though they have sophisticated drawing and technical drawing skills
- have never colored
- struggle with prayer
- never thought to combine prayer and coloring
- are antsy, easily distracted, unfocused
- have trouble finding words for their prayers
- want a way to incorporate their hands and eyes into prayer
- want to see their prayers
- are visual or kinesthetic learners
- like boundaries and form
- want the freedom not to have to create something new
- want a new way to pray
- are curious

Chapter 1

Coloring as a Spiritual Practice

Sometimes coloring is just coloring. To put crayons, markers, or pencils to paper and create a rainbow of marks and swaths is relaxing, playful, and maybe even artistically satisfying. People color while watching television and waiting to pick up children from school. Travelers in airport terminals hunch over pages as their colorful designs emerge.

Coloring offers both the delight of playing with color and the satisfaction of a finished picture at the end. It is a simple, portable way to release tension and enjoy moments of childlike and artistic pleasure.

Sometimes coloring is more than just coloring. Coloring can be a spiritual practice. To put color to paper can create a pathway to the numinous. While the hand moves across the page the rest of the body and the mind slow down. Slowing down is no small endeavor in our culture. Stimulation, gadgetry, and constant virtual connection are the norm. For many of us the transition from busyness to stillness is difficult. Since I am a restless person, mine is continuous and slow.

Coloring as a spiritual practice provides a segue between the fast, continuous movement of my normal life and a slow, contemplative pace. The delight of choosing and using colors, the motion of my hand on paper, and the focus of my eyes on the work in progress give me something to *do*

while I transition from high speed to zero, from busyness to stillness. Since chronic *doing* is the norm for most of us, coloring can be a bridge to an island of inner quiet.

And sometimes coloring *is* the island. It is a destination where stillness and presence happen together.

My definition of a spiritual practice—and I do not claim any expert knowledge—is an activity in which my mind, body, emotions, thoughts, and spirit are all in the same geography at the same time. I no longer feel like a piece of taffy pulled in many directions. For me a spiritual practice is the opposite of multi-tasking. It is gathering all the parts of me into a single place and staying there for a while. My intention in spiritual practice is to become attentive only to the present moment. The word "practice" means this is not just a one-shot event, but frequent, repeated attempts to reach this place.

If I can get to that island or oasis of stillness, and maybe even emptiness, then I can listen. I can pay attention to the desires of my heart, the messages of my unconscious, the dreams lurking on the dark side of my brain, and the nagging voices of conscience I have suppressed.

Prayer is a particular kind of spiritual practice. Prayer assumes the existence of a Higher Power, of an Other within and beyond the world of my knowing. I direct my prayers toward God. The intention and goal of this practice of prayer is not just focused attention, calm, and emptiness—it is also connection. I want a relationship with my God. I want the emptiness to be filled with and infiltrated by the power and love of God. Prayer is my effort to do this.

Here are some of the specific reasons I pray:

- To have a regular spiritual practice
- To connect and be in **relationship** with God
- To experience inner stillness and calm
- To be emptied but also to be in **receiving mode**
- To get my priorities straight
- To ask for help
- To confess the stuff I'm not proud of
- To ask for forgiveness
- To express my **concerns and hopes** for other people
- To present my needs
- To offer thanksgiving and gratitude
- To become **right-sized:** not to think too little of myself, not to think too much of myself
- To remember that my life is a tiny thing in a vast universe
- To give my fear and worry to a power greater than myself
- To have a place to dump every thought I have—the ugly and the beautiful
- To have a place to share my desires, dreams, and nagging voices
- To reevaluate my life

- To surrender my desire to fix others
- To admit my powerlessness over so many things
- To discover the power I do have
- To work on my arrogant and judgmental attitude
- To be a **dreamer**, to imagine a world beyond the apparent facts
- To seek truth

These are the reasons I pray, but *how* I pray has varied, changed, and cycled back again through the years. "For everything there is a season, and a time for every matter under heaven" (Eccles. 3:1). My spiritual practice of prayer has included words—lots of words and just a few—, psalms, songs, Scripture, movement, crying, yelling, praising, raging, sitting down, dancing, standing up, kneeling. . . . There are so many ways to pray.

In this season of my life, coloring has become a way to pray.

Chapter 2

Coloring as Prayer

I have been praying through coloring and doodling for more than a dozen years. This book is my invitation to you to explore coloring as a way to pray.

I am a lifelong pray-er. My childhood was soaked in prayer. I memorized psalms, hymns, and prayers from my Christian tradition at an early age. Prayers were the first words I remember from my mother. They grounded me in God, gave me an awareness of self, and formed my relationship with other people and the world. But I have never been an elegant or eloquent pray-er; I am a shy and fumbling-for-the-right-words kind of pray-er.

Drawing or painting anything from real life is beyond my skill level, but I love to let a pen take me on an unpredictable hike around a piece of paper. Doodling allows me to use the tools of an artist even if I don't know where I'm going or what I am trying to draw. It is a relaxing and creative form of play for me.

Prayer through doodling and coloring came to me in a time of desperation. A dozen family members and friends had become ill with a variety of lethal cancers—brain, breast, skin, lung.... The shock and seriousness of their diagnoses rendered me prayer-less. Puny one-liners made their way to God: "Please God, heal Chuck. Let Sue live to see her children graduate from high school. Take away Peter's pain. Surround Julia with your strength and your love.".... I'm sure God was fine with my simple prayers, but my words felt inadequate compared to the magnitude of my friends' illnesses.

One summer morning after a busy year of teaching community college math, I hauled my basket of colored pencils and markers and a pile of white paper to the glass-top table on the screened-in

porch of our house. Setting the table with markers and paper was my ritual announcement of the arrival of summer and three months of vacation. I started to doodle an amoeba-like shape on the paper. With lines, arcs, dots, and color, the shape grew. The name "Sue" appeared in the middle of the doodle. (Sue was my sister-in-law with stage-four lung cancer and two children still living at home.) I kept drawing, adding color, and focusing on her name. When the doodle was finished, I realized I had prayed for Sue. No words were necessary. I had spent time with her, offered her into God's care, and that seemed sufficient.

I prayed in the same way for my other friends who were ill. Each person had a colorful, personalized prayer doodle. The result of this doodling experience was both a quiet time of prayer and a visual prayer list. The page of doodles stuck in my head. During the rest of the day the names, shapes, and colors came back to me, and I prayed for my friends and family members again—with and without words. Those recurring appearances of the page in my head became visual prompts for me to pray. It was an inkling of what it means to "pray unceasingly."

My first prayer drawing looked something like this:

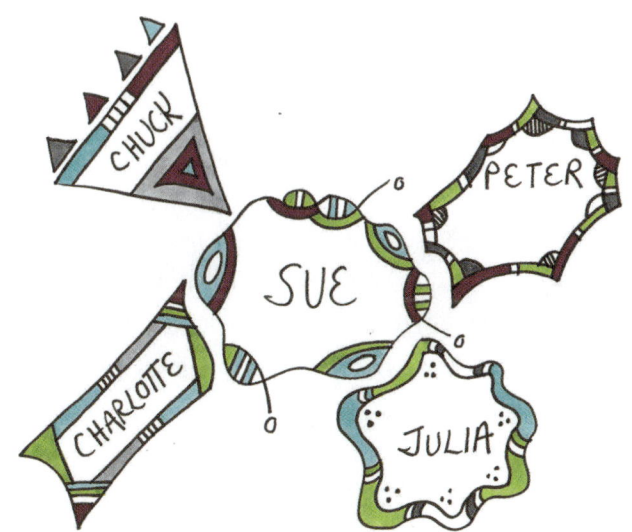

Praying in color, my secret name for these doodled prayers, became the main way I prayed for other people. For a year I told only my husband, Andy, and a close friend about my new prayer practice. To my critical, intellectual self, the whole idea seemed silly, a little too playful, and maybe even spiritually illegal. For a person who loved words and liked to write, it was an embarrassment not to be able to come up with articulate verbal prayers. But I continued to pray with doodles and color.

Here are some things I noticed over the course of the year:

- My paper, colored markers, and black pen formed a little prayer closet where I could go to get still. Even in public places people seemed to know I was hunkered over something important and did not interrupt me.
- Doodling my prayers invited my body into the prayer and helped to quiet the internal clamor and chatter.
- My body and mind were less antsy, fidgety, distracted, and unfocused than they had been during prayer time.
- Doodling allowed time for words to form and/or for stillness to come.
- Doodling became a form of listening prayer. Without forcing or insisting on words I was more open-eared and openhearted.
- A single line/dot/arc or stroke of color could feel like a nonverbal prayer.
- The vocabulary of my doodled prayers expanded from prayer for others to include gratitude, confession, and simply spending time in God's presence with no agenda.

In 2004, I showed my collection of accumulated prayers to a new friend named Phyllis Tickle. Phyllis was the first Religion Editor of *Publishers Weekly* and had written a shelf or two of books. She said to me, "You're going to write a book about this." Her statement was both invitation and commission. I started to write, and *Praying in Color: Drawing a New Path to God* was published in 2007. The book describes the process of prayer I call *praying in color*. Since then I have led workshops and retreats around the United States and in Canada. When I wrote the book and first taught *praying in color* and doodling prayer, it seemed like a radical, maybe even sketchy way to pray. Now, with millions of adults toting around coloring books and a whole community of people who write and draw in their Bibles, *praying in color* no longer feels like the weirdest prayer form in the room.

Chapter 3

The Coloring Pages / Templates

I will use the terms "coloring pages" and "templates" interchangeably. A template is a pattern or design for a specific purpose. The coloring pages in this book are designed to work as templates with prayer and prayer forms in mind. They are similar to many of my own finished doodled prayers minus the color. Sometimes when I pray I draw a whole template first and then add names, words, and color. More often, the drawing grows as I pray. I'll start with a blank piece of paper and draw/ pray for one person. When the prayer and doodle feel finished, I'll move to another place on the page and draw/pray for another person. With the one-prayer-at-a time approach, the doodling and coloring time feels like an organic, blossoming prayer. A tapestry of prayers begins to cover the page.

But there are days when I am tired or "heavy-laden." I would rather have a pre-drawn template with spaces for words and spaces for color. And that's what this book offers: ready-to-go templates. Just pick it up and start praying with words and color.

Most of the pages are drawn freehand. Some of the circles were drawn by tracing around a glass or using the shapes on a geometry template—one of those hard plastic stencil pages some of us kept in our notebooks in school. In a few I used a ruler. Templates #11 and #19 came from tracing

around a shape cut from thick paper then rotating the shape a small amount and tracing again. I repeated this process multiple times. Some of the circles, hexagons, and diamonds were generated on the computer. Most of my doodles are abstract. A few attempts at identifiable objects or creatures appear on the pages but with a sense of whimsy rather than any serious attempt at accurate representation.

These coloring pages are not meant to be perfect designs. Lines are not always straight; symmetry is off; shapes are irregular. These imperfect, irregular templates are my invitation to you to color and pray imperfectly. My pastor friend Merry says, "If it's worth doing, it's worth doing poorly." Coloring and doodling are worth doing because they are fun, playful, relaxing, and creative. Prayer is worth doing because it gathers my scattered parts, reminds me who I am, and connects me to a Power greater than myself. And sometimes it is fun, playful, relaxing, and creative. Showing up and participating is important. Creating a beautiful work of art or an eloquent prayer is not.

Each coloring page gives you some safe structure and then sets you free to pray and play. Some of the templates have lots of small, intricate spaces to color; others are more open. If the spaces are too small, feel free to cross the lines and color more than one space with the same color. If the spaces feel too large and bare, add lines, arcs, and dots to create more, smaller spaces for different colors.

Most of the templates will work for any of the prayer forms I suggest. A few of the forms are unusual and might require a special template. I will give suggestions for these.

If you want to use a particular template more than once, please feel free to make copies for your personal use. If you want to share them with your Sunday School class, Bible study, or other group project, please check the publisher's website to order multiple downloadable copies of a particular page for a small fee.

The next chapters will help you to initiate a coloring prayer practice, and will introduce you to different ways to pray through coloring. I hope you will experience these coloring pages as both playful and prayerful.

Chapter 4

Preparing to Pray

Supplies

You will need colored pencils, markers, crayons, or gel pens. If you have not colored for years or have never colored before, experiment with the different coloring tools. Decent and inexpensive brands are readily available. You can also invest in high quality art supplies.

I also suggest a black roller ball pen—just in case you want to add more marks or write words on the page.

Since the coloring pages are one-sided you can use any coloring tool without destroying the design on the other side. Some pens and markers bleed, so it might be helpful to place a blank sheet of paper behind a template to soak up any color that might seep through to the next page.

If you are at home, find a quiet place to go with your coloring book. To segue from what you were doing previously to this time of prayer, you might want to light a candle, take a deep breath, shake your arms, legs, and shoulders, or say an opening prayer. If there is no quiet place where you live, just hunker down over your coloring page. In Matthew 6 in the Bible, Jesus advises, "But when you pray, go into your room [or closet] and shut the door." In a pinch, a table or a clipboard can be your prayer closet. Act as if you are doing something focused and important. (You are!) Other people will get the message and leave you alone.

Beginning to Pray

Begin your prayer time with the focus on God. Choose a template and choose a shape or space in which to write the name you like to use for God: *God, Holy Spirit, Jesus, Beloved One, Creator, Higher Power....* Many of us have a word or name we most often use for God. After you become familiar with the process of using the coloring pages, try new names for God, maybe some that intrigue you or even feel uncomfortable. Add adjectives to your usual name: *Transforming Spirit, Loving God, Awesome Creator, Gracious Light....*

As you write the name in the space, offer some verbal prayers if you like. Say, "Be with me now"; "Open my heart"; or "Help me to listen." Remember, words are not necessary. Focus on the name and start to color. Say the name over and over if it helps you to concentrate. If words come to you, pray them. Write them down, if you like, anywhere on the page. If no words come, just think of each stroke of color as a non-verbal prayer. Imagine yourself in a room, you and God together, just being there with or without words. If you don't know when to stop your prayer, use a timer. Set it for three minutes. I like to use an old-fashioned egg timer and watch the grains of sand drop. A time constraint can make the process feel safer. If you finish before the timer has finished, challenge yourself to keep coloring/praying, or sit and look at your name for God and your completed coloring until the timer goes off.

Now move on to the particular kind of prayer you want to pray.

Chapter 5

Ways to Pray

This chapter describes a handful of the many different kinds of prayer. Each of the following ways to pray has a partially colored example and suggestions for which templates are best suited to use with it.

To begin any of these prayer forms:
- Choose a template.
- Spend some time centering on God as described in the previous chapter.

1) Prayers for Others

Praying for other people is called *intercessory prayer*. We pray for others for a multitude of reasons: physical healing from illness, safe travel, healthy pregnancies, and happy and stable marriages. We pray for them when we think their lives are out of kilter, when we think they are making terrible mistakes.

To create an *intercessory prayer*, write the name of someone you want to pray for in a space on the template. Start to color. Focus on the name of the person. If verbal prayers come into your head for the person, say them. If it seems right to you, write the words in or around the shape. Do not force words or think you are a bad pray-er because eloquent phrases do not burst from your mind and heart. As you color, settle into the silence. Maybe there will be an ebb and flow between words and no words.

If you get distracted by noodlings in your head like, "I need to pay the bills," or "Make an appointment with the vet," or "I didn't eat breakfast," find a place to list your distractions. I often make a little box in a corner of the page. Or delegate one of the spaces on the template for "Distractions" and write them as they pop up. Then keep praying.

Sometimes I have an agenda or expectations for the people I'm praying for. I want them to get well physically, go into recovery, find a new job, or stay married. I think I know what they need and what is best for them. Often I am wrong. When you pray for a person, be honest. Say what you really think, pray for what you really want, and then let it go. Part of the idea of coloring as prayer is to give you time to say what you want and then to release the person into God's care. When I color I try to shut up and listen, to let go of what I think another person needs.

When you feel like you have finished praying for a person, take a breath. Then shoot off a little one-line prayer or passage of Scripture to God, or say an "Amen." Next move to a different place on the page and pray for someone else. You can always return to the first person at another time. Repeat the process for as many people as you want. Your prayer page can include just one person or many people. You can color the entire page in one sitting or you can return to it another time or another day. One page of coloring might be from a single time of prayer or a week of prayer sessions. It's up to you.

At the end of a coloring session go back and revisit the people you prayed for. Sit with each person for a few moments and offer a final blessing.

As an example of *intercessory prayer* I used Template #1 and colored markers. Many of the other templates in the book will also work for this prayer form.

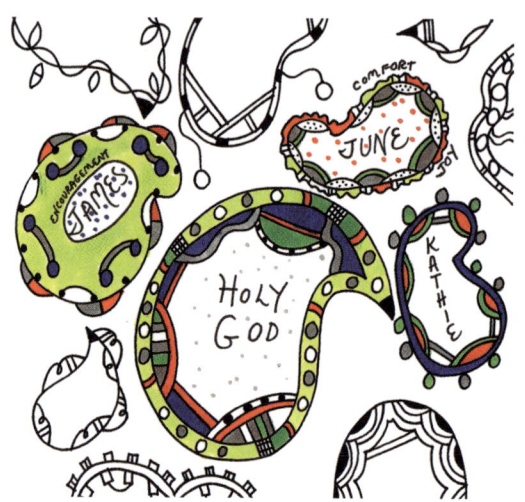

2) Prayers for Myself

Sometimes the person I need to pray for most is me. These are sometimes called *prayers of petition*. I want to give God my questions, feelings, and concerns. Some of my prayers are about today and the near future: "How will I make this deadline?" "Help me to create a welcoming

atmosphere for the dinner party on Saturday night." "Do I need to do anything about the pain in my top left molar?" Some are for long-term concerns, about getting old, where I should live for the next ten years, what I will be when I grow up, or if I'll ever grow up.

My character defects are a constant topic of prayer. These are the entrenched habits and personality traits that keep me from being the person I believe God created me to be. My impatience with others, my failure to think before I speak, my disdain for people who act old before their time, and my fear of people different from me are lifelong issues. They require ongoing attention, and I keep offering them to God for healing and cleansing.

To pray for yourself, write your own name, or "Me," or some other way of designating yourself on the template. Start to color. Write words for the things you want to share with God—your character defects, concerns, or questions. I like to write words and add the date. The finished drawing is like an entry in a prayer journal. But don't force words; sometimes coloring and listening are prayer enough.

Here is a prayer for me using Template #2 with colored markers.

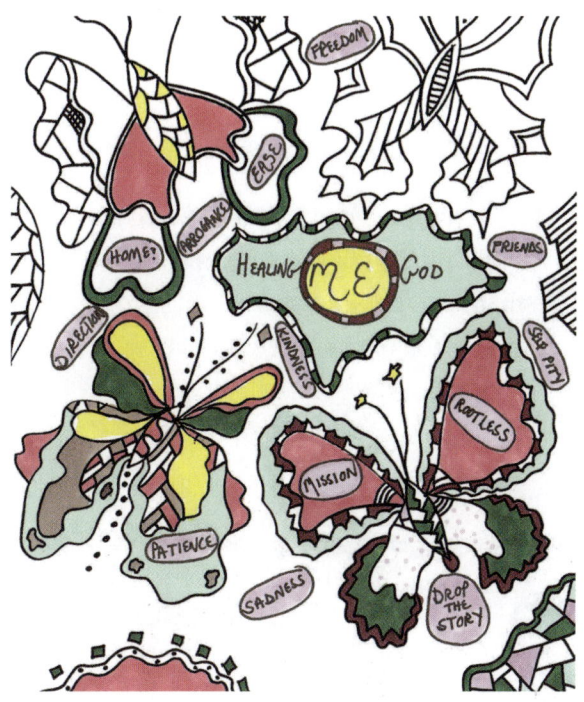

3) Disgruntled Prayers

God can handle whatever we bring to him in prayer. Some days we just want to dump all of our complaints, whining, grumpiness, and misery on God. Have at it! Write all of your negative baggage on your prayer page. Then color. Don't hold back. God can take our garbage and turn it into compost. Hang onto the prayer for a day, a week, or a month; then, if you have a compost pile, bury it there. Who knows what fertile things will come from that prayer.

Giving myself permission to be grumpy and whiny with God has made my prayers feel more authentic. It probably also helps me to complain less to other people.

I used Template #3 with colored pencil.

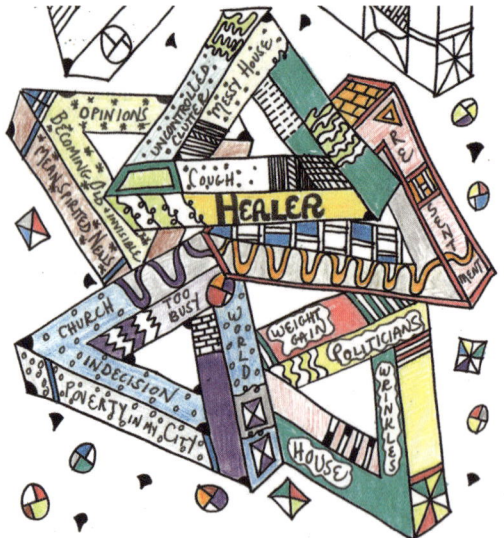

4) Gratitude or Gruntled Prayers

Fill the page with the things for which you are thankful. Gruntled and disgruntled prayers often go hand-in-hand. We can be both grateful and grumpy with a God in whom we trust. Listing our grievances one time and our thanksgivings another is an effort to have an honest and intimate relationship. Express your gratitude for the simple and everyday stuff as well as the cosmic and profound.

This prayer used Template #4 with colored marker.

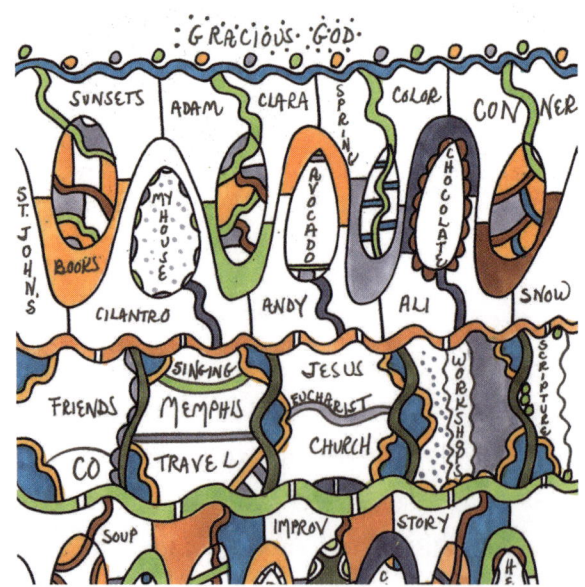

5) Adoration or Praise Prayers

Adoration is a time to sing God's praises. Write words, phrases, and names to describe God. Tell God of your admiration, love, and devotion—a valentine to God. Saying words of admiration and adoration can be hard and embarrassing for those of us who are shy. So think of each stroke of color as waving a banner for God. Or imagine that you are creating a beautiful piece of art for God. If you are a person who is not sure how you feel about God, write honest words. Don't force words that aren't there. Just color and be open to other thoughts and words.

The example below uses Template # 5 and colored pencils. I added a few lines and arcs with a black pen to create more spaces to color.

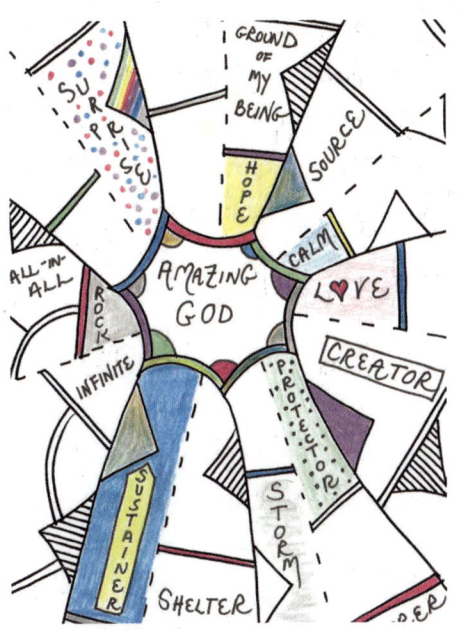

6) Confession or Regret Prayers

Confession is an opportunity to name the things I regret and to ask for help and forgiveness. Seeing these things in print surrounded by color makes them more real for me. When I confess only in my head or with my mouth I am more likely to forget the ways I miss the mark or the things I have done and the things I have left undone (*Book of Common Prayer*, 1979, p. 293). The coloring page is a visual reminder to me to work on those things.

When I make a confession in prayer I feel a huge release. Not only am I asking for forgiveness; I am asking for accountability. I want God to help me with the long process of changing the things I confessed and amending my life.

You can list the things you are sorry for in the boxes or shapes. Listen to what they might have to say to you or what God might have to say. Including "I am" or "I'm" is more difficult and powerful for me than just making a list. It is easier for me to say "Sorry" than "I'm sorry." So I challenge myself to say "I" and take ownership of my regret.

The prayer below is an example of a child's confession in crayon on Template #6. For kids I call these confessions "I'm Sorry" prayers.

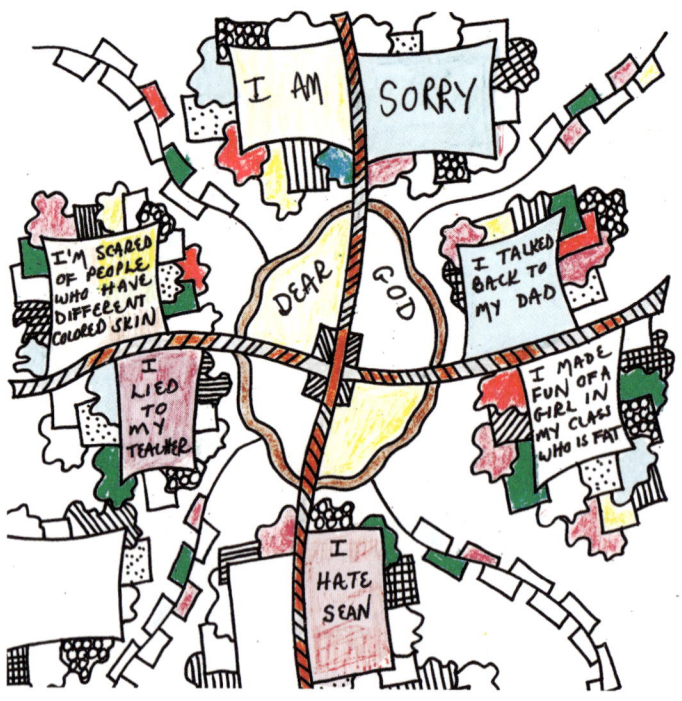

The prayer below on Template # 7 is an example of an adult confession in colored marker and pencil. The quotation at the top based on Matthew 8:8 is from the Roman Missal, Third Edition.

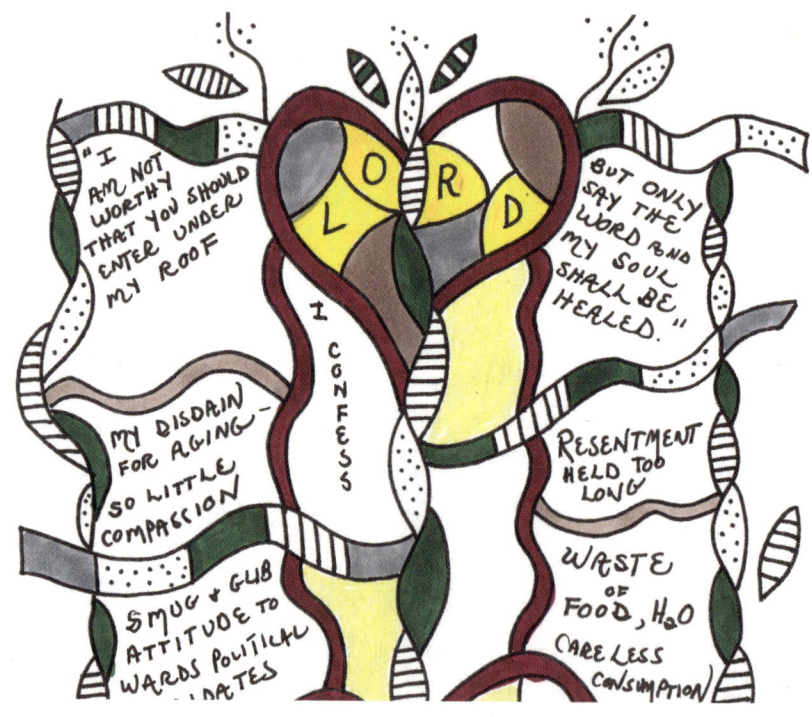

7) Spending-Time-with-God Prayers

To spend time with God with no particular agenda can create an opportunity for your soul and spirit to catch up with your mind and body. Pick a template, write your name for God, as you would to start any type of coloring prayer, and then just start to color. Rest in the gentle movement of your hand, in the colors you have chosen. Stay open-eyed and open-eared to the presence of God. Keep a soft focus, one that allows lots of information to come in through all channels of your being—your senses, your mind, body, and heart. If something you perceive seems important, write it down. You can spend time with it in prayer right then or come back to it later.

I used markers and gel pens for this prayer. One way to color in a space is by filling it with small circles, lines, and dots. This is Template #8.

8) Blessing Prayers

In a blessing prayer we address a person directly and ask God to bestow certain good things upon them. When I pray this way I feel like I am anointing a person with something holy and acting as an agent of God's love. A famous prayer of blessing is from the Book of Numbers:

The Lord bless you and keep you;
the Lord make his face to shine upon you, and be gracious to you;
the Lord lift up his countenance upon you, and give you peace.
Numbers 6:24–26

You can write these words or come up with your own. My prayer alternates between coloring and writing the words of blessing on the page. I love to send blessing prayers to people as birthday or get-well cards.

This blessing prayer is for a young mother with cancer. I used Template #9 and colored markers.

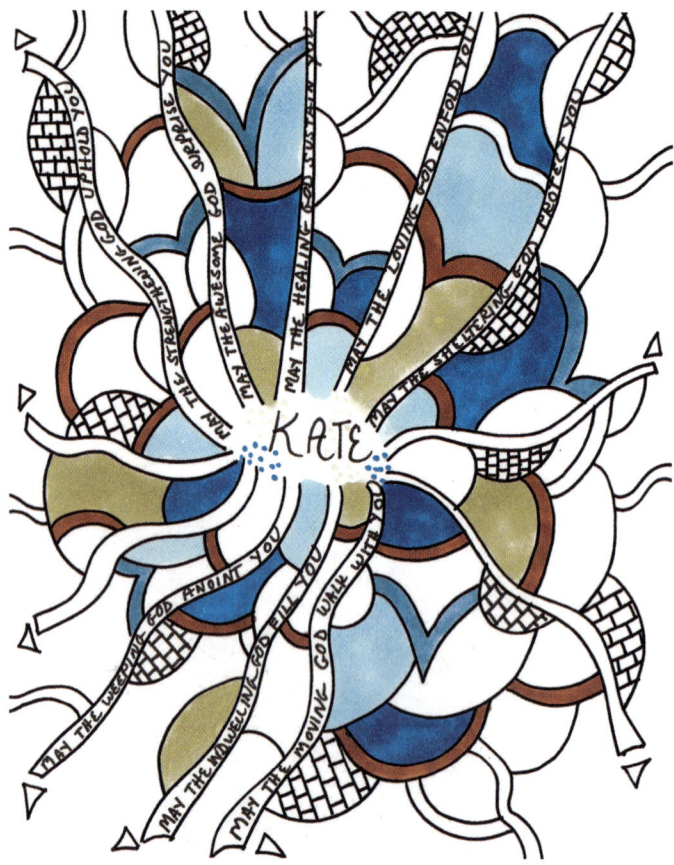

9) Praying for Your Enemies

"Love your enemies, bless them that curse you, do good to them that hate you, and pray for them which despitefully use you, and persecute you" (Matt. 5:44 KJV). These are tough words from Jesus. Praying for someone I dislike or who has hurt me is not something I want to do. It calls for a radical hospitality I do not possess. I do not want to offer a prayer for my enemy's well-being or welfare; I do not want my enemy in my house, let alone in my mind. My gut response is, "Keep out. Go away." But I shoot off a few words of prayer to get off the hook with Jesus, to comply with the letter of the law. "God, be with _____." But I know this is not enough. My disdain and hatred return.

So here is a way I try to face an enemy head-on in prayer. Even though it uses the playful act of coloring, it does not feel playful. I have to spend time with the person I resent. I have to look at the name over and over again; I have to invite the person to enter the privacy of my prayer closet.

So be warned, if you try this prayer it might turn your stomach. Unlike a prayer of words in your head, it won't float away. It will stare you in the face and may even try to stare you down. You may need to spend a little *extra* time with God before you name the person.

Try this with Template #10 or #26. In the space on the right side of the page, write the name of the person for whom you will pray. If you don't want anyone to see the name, use code or initials. Then color. Breathe and listen. When feelings arise about the person, jump to the left-hand column and write

them down. Write the things you dislike about the person and the qualities you admire. Stick with the feelings and the qualities. Stay away from rehashing the story of offense or hurt. Keep coloring. Arm yourself ahead of time with a short prayer or line of Scripture to interrupt the replay: "You strengthen me more and more; you enfold me and comfort me" (Ps. 71:21, *Book of Common Prayer,* p. 684).

If you are brave, keep the prayer drawing within view and say a small prayer whenever you look at it: "Heal my heart." "Teach me to let go." "Surround us with love." For me this is almost never a one-time prayer. Forgiveness is a process. Sometimes I discover that there is no need for forgiveness—I am just hurt and the person did me no intentional harm. If I can start to see the person as an "image of God," instead of a villain, I know the healing has begun.

In this prayer for an "enemy" on Template #10 I used colored markers and oil pastels.

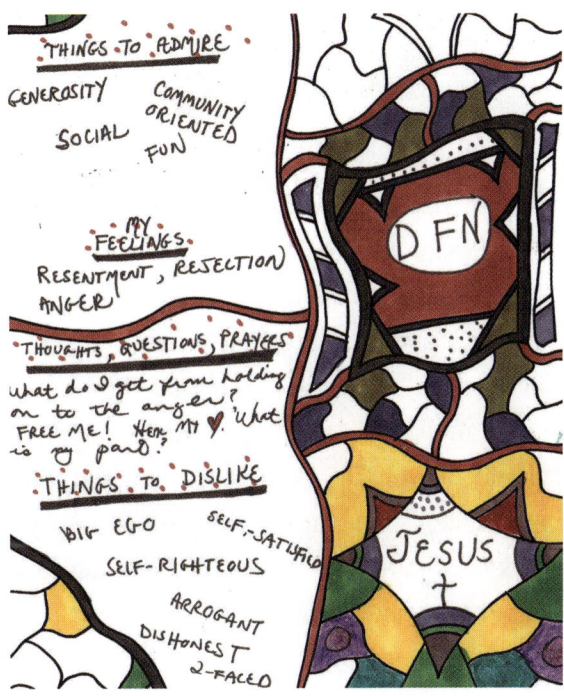

10) Praying a Passage of Scripture

An important part of my childhood religious education was the memorization of prayers, hymns, and passages of Scriptures. These memorized lines and verses gave me a vocabulary of faith. They are part of an internal spiritual treasure chest I carry with me wherever I go. When my own words fail—which is frequently—they provide comfort and encouragement.

If you want to "read, mark, learn, and inwardly digest" (Proper 28, *Book of Common Prayer*, p. 236) some words of Scripture or other inspirational passages, write them on one of the coloring pages. Read the words over and over to yourself or aloud. Color as you let the words sink in. Repeat a portion of the words until you can say them without looking. Use a highlighter to break up sections or to emphasize words. Keep coloring while the words become part of you.

This example uses Template #11 with markers, highlighters, and gel pens.

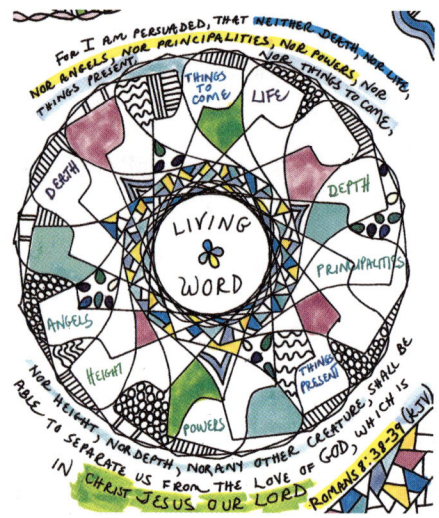

11) Praying Your To-Do List

Whether your to-do list for the day is bouncing around in your brain or written on a piece of paper, offer prayers for each of your tasks. Some may not seem worthy of prayer—doing the laundry, going to the bank, calling your Internet provider. But any one of those tasks can be an opportunity for frustration: my husband didn't turn his socks right side out again; the drive-in line at the bank is slow and inefficient; the representative on the phone doesn't understand the problem I am having with my cable system. These seemingly simple situations can turn me into an inner and outer grouch. I resent doing the laundry. I'm short with the teller, and I want to yell at the person on the phone. Praying ahead of time can at least warn me of a potential snarky response that could ruin my day and the day of someone just trying to do their job. My menial to-dos, doused with a little prayer, become invitations into kindness.

Write those "little" tasks in small spaces on a template. Reserve the bigger spaces for the more serious things on your to-do list: a presentation at work, jury duty for a serious trial, playgroup for five wild toddlers at your house, an interview for the job you really want and need, a trip to the doctor for a cough you have had for months. Color around the spaces. Write your words of concern or feelings near the task. Let God permeate your daily to-do list.

This "to-do" list example uses colored markers on Template #12.

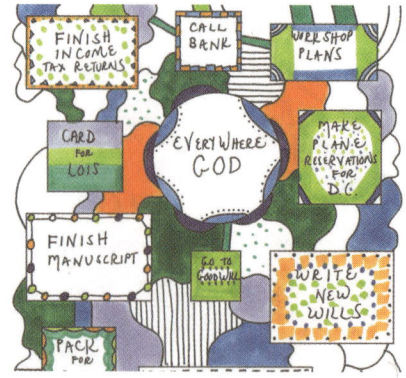

12) Daily Inventory Prayer—The Examen

A logical companion prayer to the to-do list prayer is a nightly spiritual inventory—a way to examine our day in the bright light of God's loving scrutiny. Its fancy name is the Examen. St. Ignatius, who started the Jesuit order, introduced this daily (and sometimes twice-a-day) practice more than five hundred years ago. When a company takes an inventory of its products, it looks at both its surpluses and its shortages. The Examen asks us to remember and revisit our experiences of *connection* and *disconnection* in relationship to God.

I think of this as the 180° prayer. First you look backward to review the road you have taken on this day; then you look forward toward a new day and the road ahead.

Here is one version of the five basic steps of the Daily Examen:

1. Ask for God's presence.
2. Give thanks for the day.
3. Review your day with a focus on where you felt connected to God and where you felt disconnected from God. Notice the feelings you have as well as the details.
4. Choose one of the especially poignant experiences of *connection* or *disconnection* and give it special prayer attention.
5. Look forward to the day to come and ask for God's direction and guidance.

The Daily Examen cultivates a way of seeing our lives as inseparable from God. It teaches us to say "yes" to God's request to be a constant companion on our daily journey.

To pray the Examen or take a daily inventory via coloring, work through the five steps of the prayer something like this:

1. Write your name for God in a space. (This is the first step in all types of coloring prayer.) Ask for a spirit of openness to hear God's voice. Saying Psalm 139:23 might be a helpful way to begin: "Search me, O God, and know my heart; test me and know my thoughts." Pray and color.
2. In or around the shapes, write things from this day for which you are thankful. Color. Listen for things you had not thought of.
3. Write words or short phrases on the page to describe your experiences of *connection* and *disconnection.* (Look at your to-do list if it helps you to remember.) Color, think, and listen. Write impressions and feelings.
4. Hunker over your coloring page around one of the experiences from step 3 that grabs your attention. Color and listen. Pray a prayer of gratitude, confession, or adoration if appropriate. If more thoughts, words or feelings come to you, write them on the page. Color and listen. Repeat.
5. Ask for guidance for the day to come. Color. Listen for possible items for tomorrow's to-do list or maybe tomorrow's "how to be" list. Take a breath. Say "Thank you" and an "Amen."

Taking this spiritual inventory on a coloring page helps me to see and organize my thoughts. And I can keep the pages as a visual diary of my experience of God.

If a daily Examen seems overwhelming, try it as a weekly or monthly discipline. A larger piece of paper may be necessary!

Here is an example of this prayer on Template #13 with colored markers.

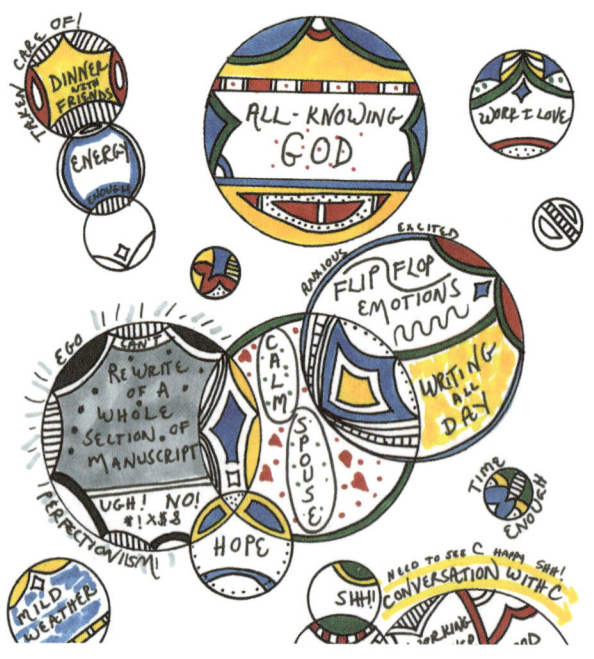

13) Hodgepodge Prayers

If you pray like I do, most of your prayers are probably a hodgepodge of everything on your heart and in your mind. All in one sitting, I might pray for other people, for myself, for my regrets, for my thanksgivings, and for God's greatness. Here is an example with Template #14 using crayons:

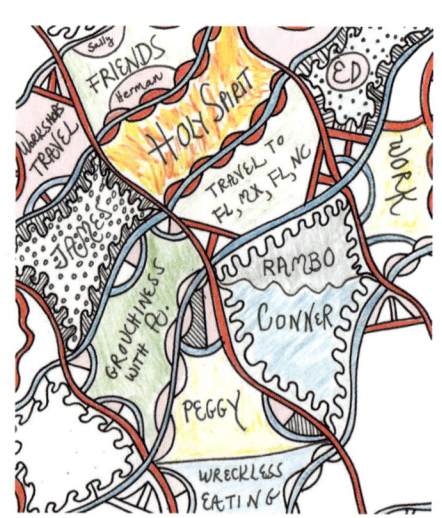

14) Praying in Calendars

Calendar templates work well for hodgepodge prayers. I first used calendars as a format for prayer years ago during Advent (the weeks before Christmas) and Lent (the forty-plus days before Easter.) Each day I used the designated space and prayed for a person or reflected on a word from Scripture. The little boxes and shapes provided a manageable amount of space and a daily discipline I could complete in a small amount of time. Here are examples from a previous Advent and Lent:

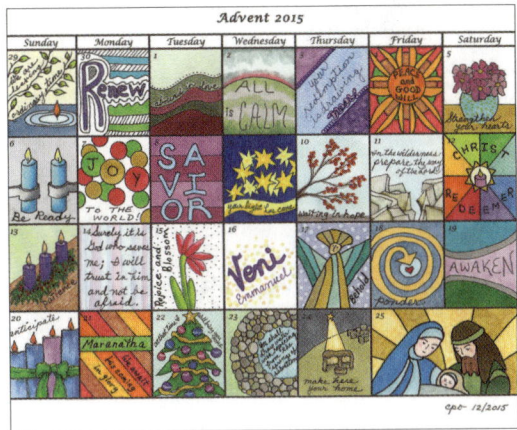
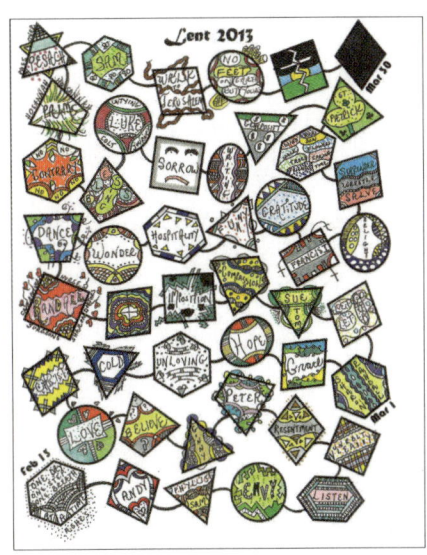

The finished 2015 Advent calendar is by Cindy O. Check out her blog about drawing: mostlymarkers.blogspot.com
The Lenten calendar is mine.

Templates #30 and #31 are calendars for Advent and Lent. The Advent calendar has twenty-eight spaces since the number of the days in Advent varies yearly from twenty-two to twenty-eight. The Lenten template has forty-six spaces—the forty days of Lent plus the weekends. The spaces on these calendars are small. I like to use a commercial printer and expand the size of the template from an 8.5" x 11" piece of paper to an 11" x 17" piece of card stock. The spaces are larger and the paper is more durable, to last through the weeks of Advent and Lent. I also post new downloadable templates for Advent and Lent each year on my blog: prayingincolor.com/blog

But there is no need to wait for the special liturgical seasons of the year to use a calendar. You can use a calendar to pray anytime of the year. The accumulation of all kinds of little visual prayers is, for me, a mini spiritual autobiography. The daily boxes or shapes form a tapestry of what is happening in my life and even in the world. It is a reminder of the people, places, and things in my head and on my heart.

Template #32 is a two-week calendar. There is a box for the name of the month and room under the name of the day for the date. You can copy it and reuse it for each new two-week period. Each day you can pray for a person, ponder a word of Scripture, write a quality you would like to demonstrate that day—make it a hodgepodge of your spiritual life. Pray and color.

Chapter 6

Prayer + Coloring + Doodling = Praying in Color

After you have used the templates in this book, you might want to draw your own prayers or coloring pages.

Here is a simple way to get started with an Intercessory Prayer:

1) Write your name for God on a blank piece of paper. Draw a shape around it or just start to doodle. Add marks, shapes, and color. Focus on the name you chose. Ask God to be part of your prayer time with or without words. If words come, pray them in your head or write them down. If words do not come, know that God is with you in the silence.

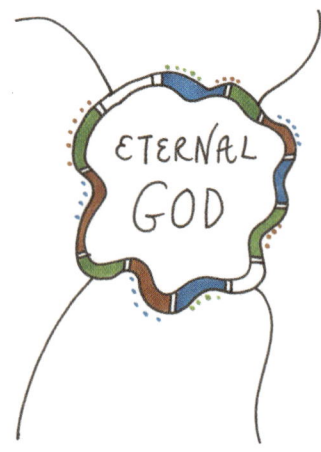

2) Draw a shape and write a person's name in it. Or write a person's name and doodle around it. Add color. Think of each mark and each stroke of color as a nonverbal prayer. Keep doodling or drawing as you release the person into God's care—with or without words. When you have finished your prayer for the person, say "Amen" or a short verbal prayer.

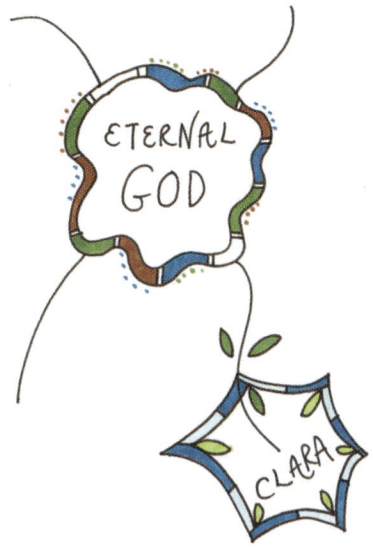

3) Add other people to your prayer drawing one at a time using the ideas in step 2.

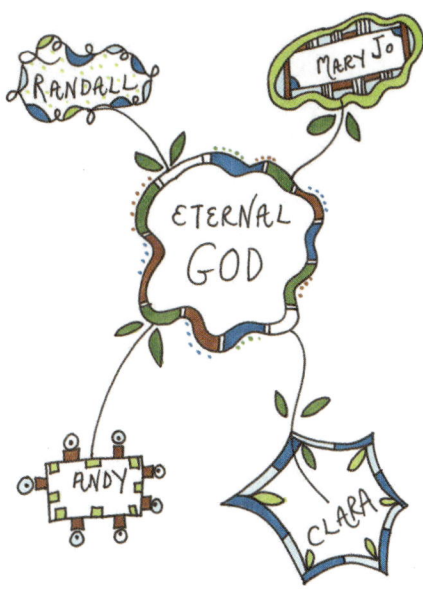

For more ideas about prayer, coloring, and doodling, check out *Praying in Color: Drawing a New Path to God* (Paraclete Press, 2007) or *Praying in Color: Drawing a New Path to God, Portable Edition* (Paraclete Press, 2013) to help you. My website and blog at prayingincolor.com also offer ideas and free downloadable templates.

#2

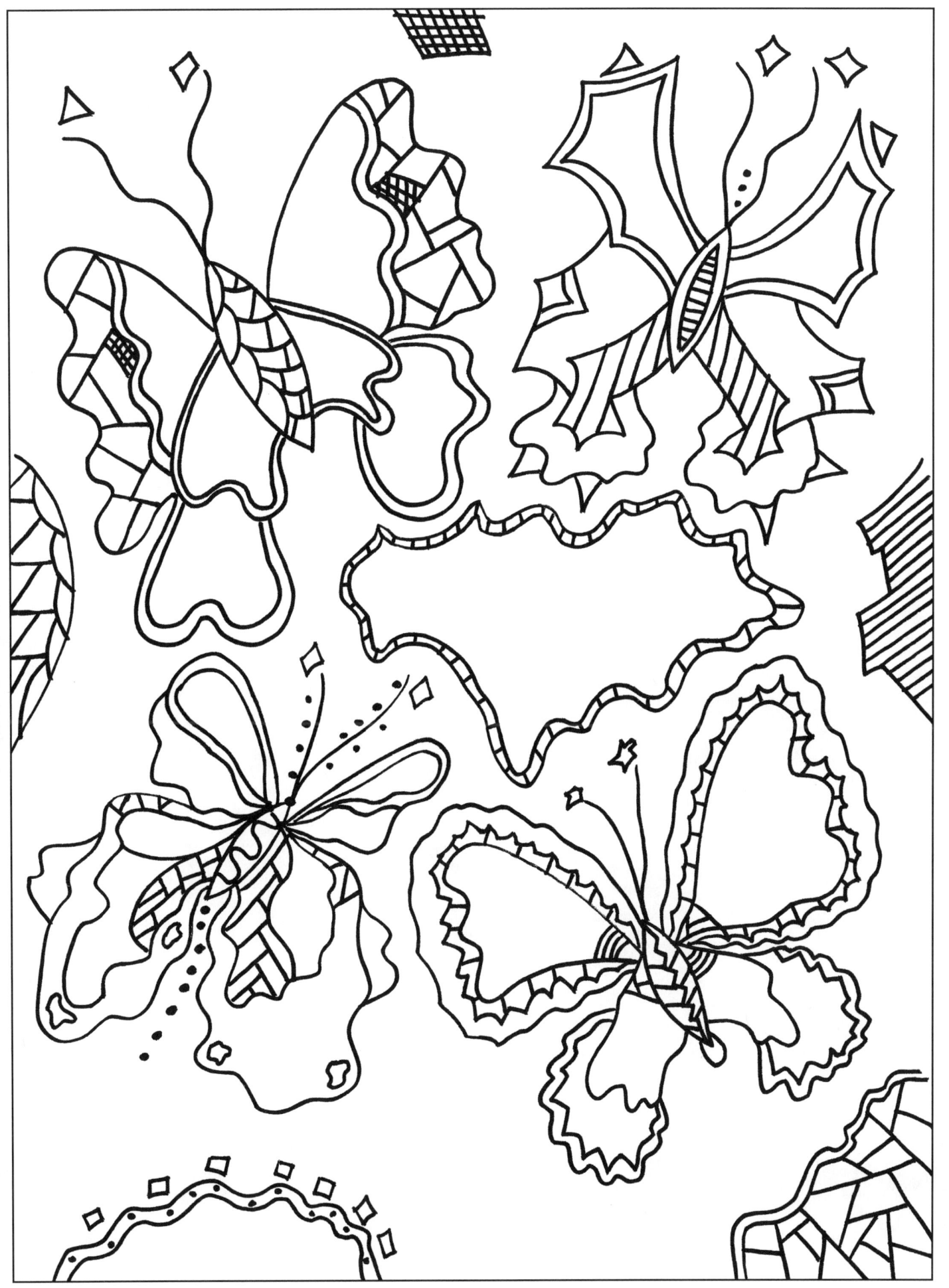

#3

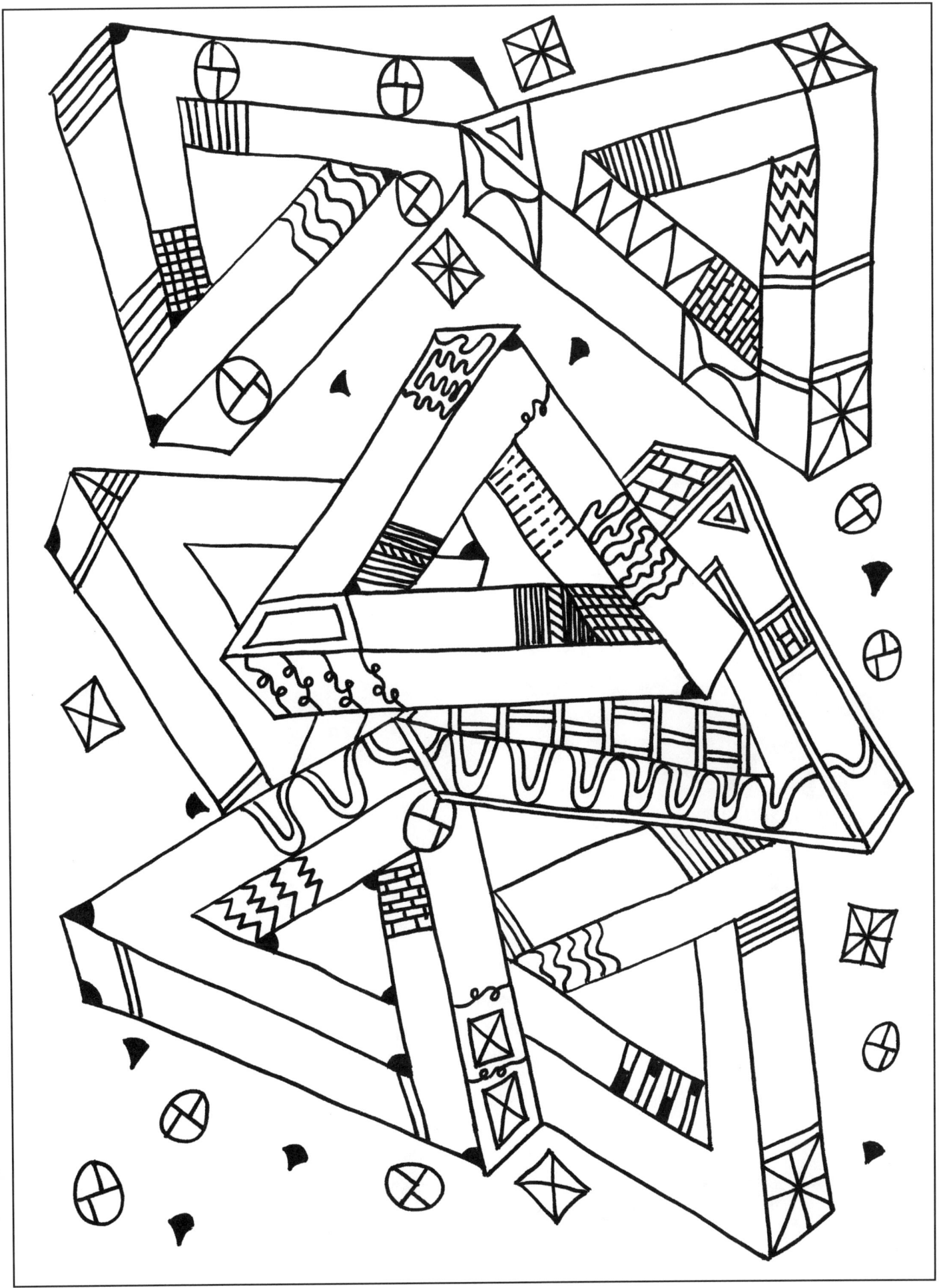

#4

#5

#13

#14

#15

#16

#17

#18

#19

#20

#21

#22

#23

#24

#25

#27

#28

#29

#30

Advent

#31

LENT

#32

Sunday	Monday	Tuesday	Wednesday	Thursday	Friday	Saturday